The Invisible Stranger

RUSSELL BANKS
ARTURO PATTEN

The Invisible Stranger

The Patten, Maine, Photographs of Arturo Patten

HarperCollinsPublishers

Arturo Patten was assisted in his work by Nico Tucci.
The photographs were printed by Giancarlo Luly.

HarperCollins books may be purchased for educational, business, or sales promotional use. For information please write: Special Markets Department, HarperCollins Publishers, Inc., 10 East 53rd Street, New York, NY 10022.

FIRST EDITION

Designed by William Ruoto

LIBRARY OF CONGRESS CATALOGING-IN-PUBLICATION DATA
Banks, Russell, 1940–
The invisible stranger : the Patten, Maine, photographs of Arturo Patten / Russell Banks. — 1st ed.
p. cm.
ISBN 0-06-019234-8
1. Patten (Me. : Town)—Social life and customs—Pictorial works—Exhibitions.
2. Patten (Me. : Town)—Biography—Pictorial works—Exhibitions.
3. Landscape—Maine—Patten Region (Town)—Pictorial works—Exhibitions.
4. Patten, Arturo—Exhibitions. I. Patten, Arturo. II. Title.
F29.P33I55 1999
974.1'3—dc 21 98-49395

99 00 01 02 03 ❖/HP 10 9 8 7 6 5 4 3 2 1

To Jane Alice

1

For several months now I have lived among the citizens of Patten, Maine. Their portraits are pinned to the rough plank walls of my cabin studio, where I write these notes, in the wooded Adirondack hills of upstate New York, in a landscape very like theirs—tilted, hardscrabble farmland abandoned early in the century and gone back in recent years to second-growth forests of spruce and pine, maple, oak, and birch trees. The pale November light outside my cabin falls at the same oblique angle as it does in their town, a hundred miles to the east, and the autumn wind blows down from Quebec here just as it does there, turning one's thoughts to winter, to the coming darkness, snow, and ice—as if the long shadow of a glacier creeping south has fallen across the valley, giving one not a warning of what will soon happen, but a prelude to it.

These isolated, north-country towns—mine in upstate New York and theirs in Maine—are shaped mainly by geology and weather, and the

region is not so much an economic or cultural zone as it is a climate. The people who live here, squeezed between the vast Canadian Arctic and the more temperate, densely populated tier of American states below, are shaped by the same strict forces as the land, and thus in many ways they have come to resemble it. They are tough, unyielding, and stoical. They are not expansive or courtly or particularly generous, for their passions have been dampened by constant expectations of disappointment. They do not so much anticipate death as expect it, and their life's hard work is to prepare for death, just as their year's work is to prepare for winter. Whether they are Catholics of French-Canadian descent or the Presbyterian and Congregationalist grandchildren of Scots from the Maritime Provinces or fallen Yankees or even lapsed Episcopalians and agnostic ex-Unitarians, these people, I and my neighbors both, are the true inheritors of seventeenth-century New England Puritanism.

Over the intervening centuries, however, a religious culture has gradually been replaced by a cultural religion, and, more so here than anywhere else in North America, that religion is a detailed reflection of the environment. It is an ancient and ongoing internalization of the physical world that surrounds us—glacial till, moraine, esker, kame, and monadnock, icy streams that tumble across

crumbled gray talus to the distant sea, dark valleys cloistered behind steep short hills, and the tree-ragged horizons that loom over the towns and offer, even in summer, not openness, but closure. We do not live *on* this land, we live *in* it. Many of us raise our families in house trailers on cinder-block foundations on half-acre roadside weed lots at the edge of town, and our white clapboard colonial-style houses on Main Street have flapping sheets of polyurethane tacked to the windows; we drive the narrow, winding roads in pickups and 4 × 4s and rusting station wagons, we dine out on fast food and buy our weekly groceries at the local Grand Union; we have satellite-dish antennas on our rooftops and watch ice hockey and professional football and laugh-track situation comedies and soap operas on TV; we bowl on Friday nights and drink too much beer and worry that our children will become drug addicts. But despite all, we're Puritans.

We are not a residual population of Puritans, however, one of those long-isolated remnant peoples practicing half-forgotten rites and mumbling atavistic prayers and hymns to lost gods. No, we merely know what's right and what's wrong; we can declare it outright and do, often and loudly, for we have a firmly established and managed hierarchy of values that we strive to live by, one that suits our weather and geology—and thus our

economy and history—perfectly. The rural and small-town people of the American north country, from Maine across New York State through Upper Michigan all the way west through the Dakotas to Washington State, are the true American Puritans. And we represent not the end of Puritanism, but its modern avatar.

But our covenant is not with the God of Abraham. Not anymore. It's with the land and with the harsh values and violent temperaments of the people who have lived on that land for the past three centuries, the people who, practicing northern European religions, migrated from their homelands and displaced the peoples who had drifted here from Asia eons earlier with their own native religions and hierarchies of value, which were no more or less naturally suited to the land and the geology they found here than were ours. They adapted; we have also. We are wintry people, stone people, tillers of thin soil, woodcutters, wall builders, hole diggers, and we are men and women and children of the book, and that book is the Christian Bible dimly remembered, crudely interpreted, and inconsistently applied in the late twentieth century to our ambiguous, conflicted, complex lives: We are thus a guilt-ridden, dour people of high standards and low expectations, and consequently we are often an angry, repressed, cruel people, whose laughter, whose sexuality and

appetites and worldly ambitions are frequently marked and sabotaged by a dangerous mania and sometimes violence. But we have adapted.

All this you can see, if you look closely and long enough, at the faces of the people of Patten, Maine—in the photographs that have surrounded me in my cabin these past few months.

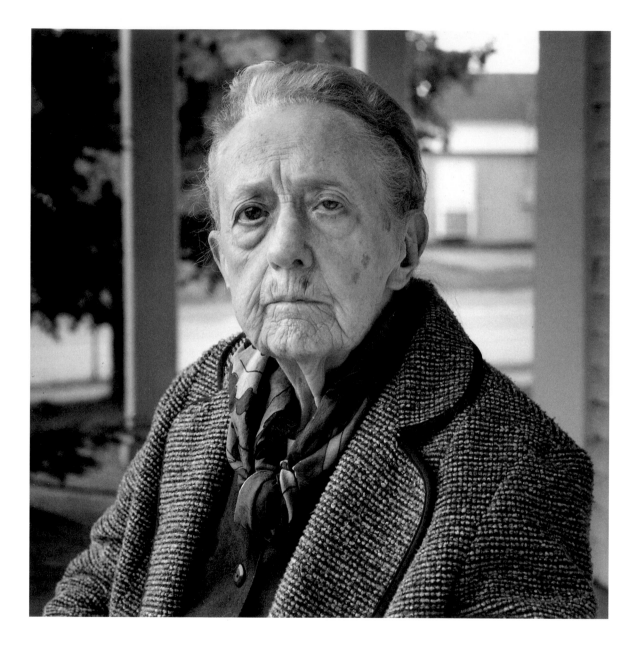

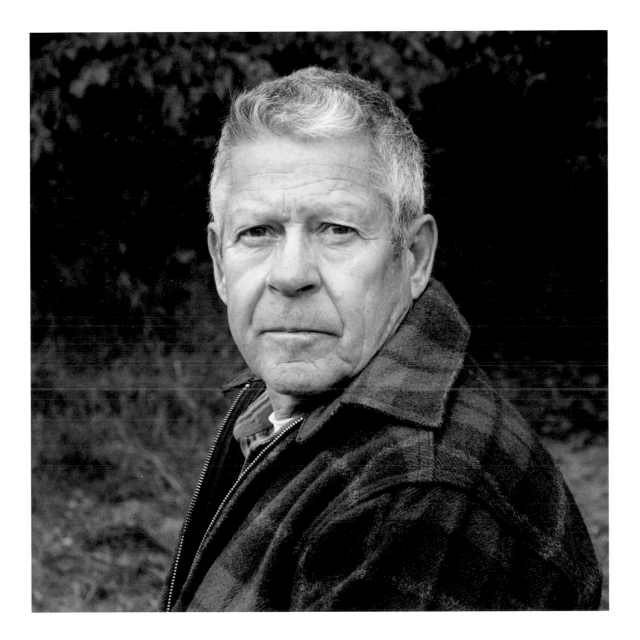

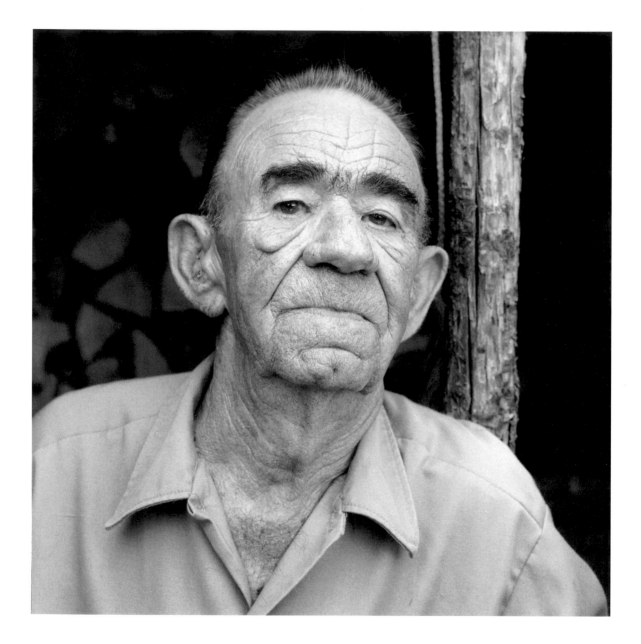

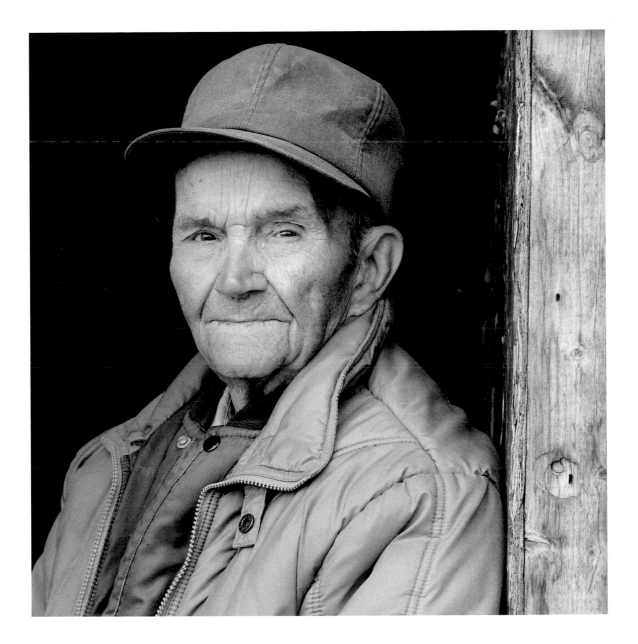

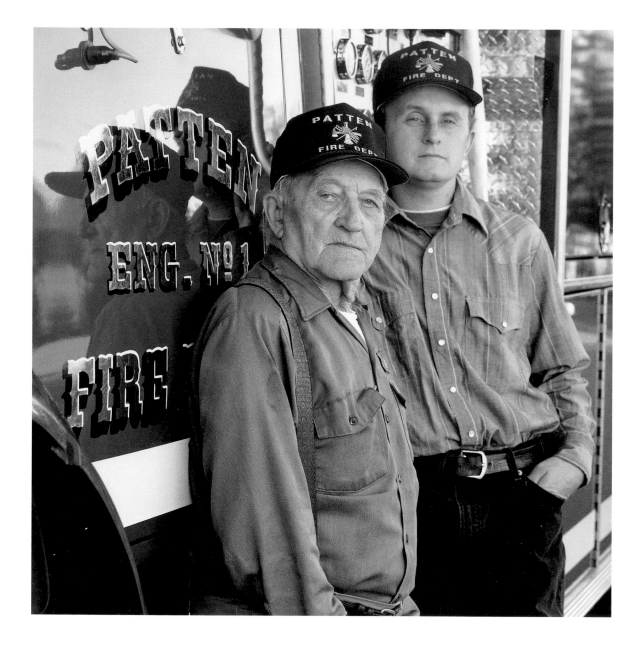

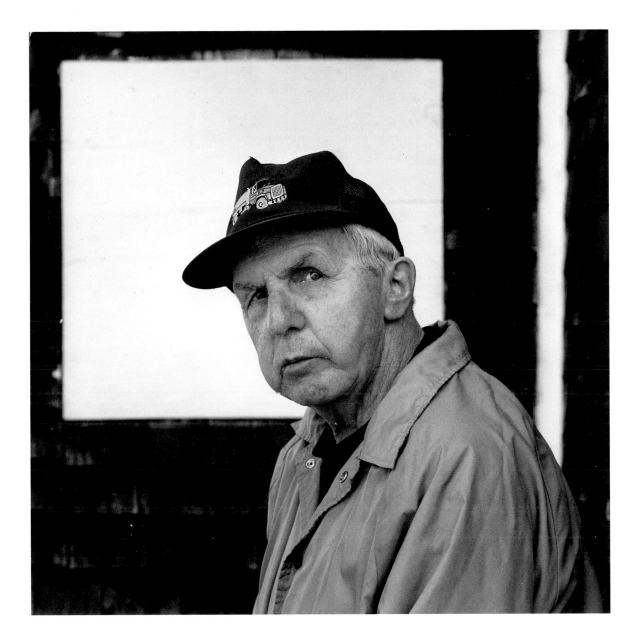

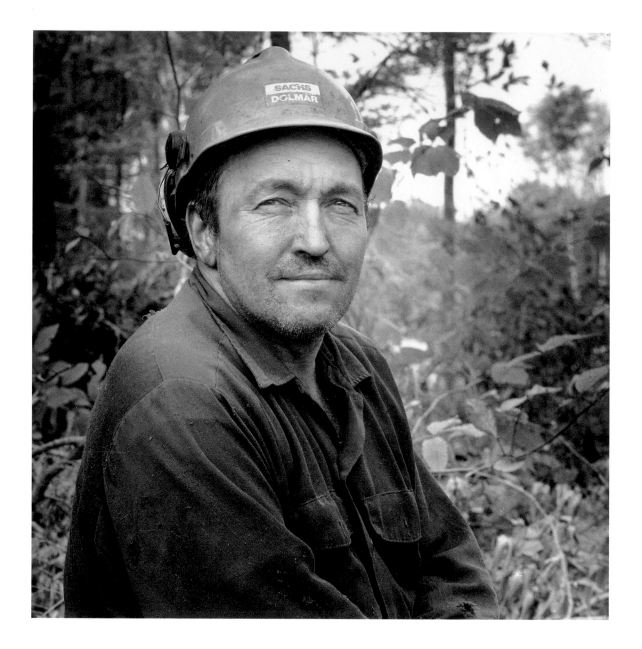

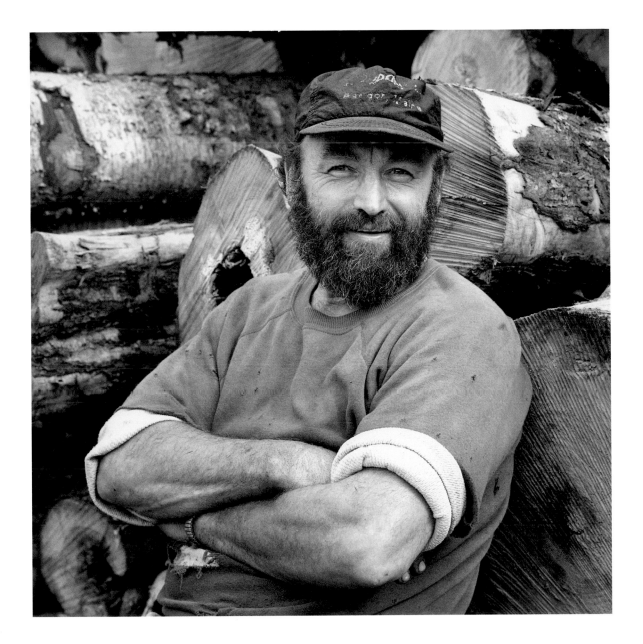

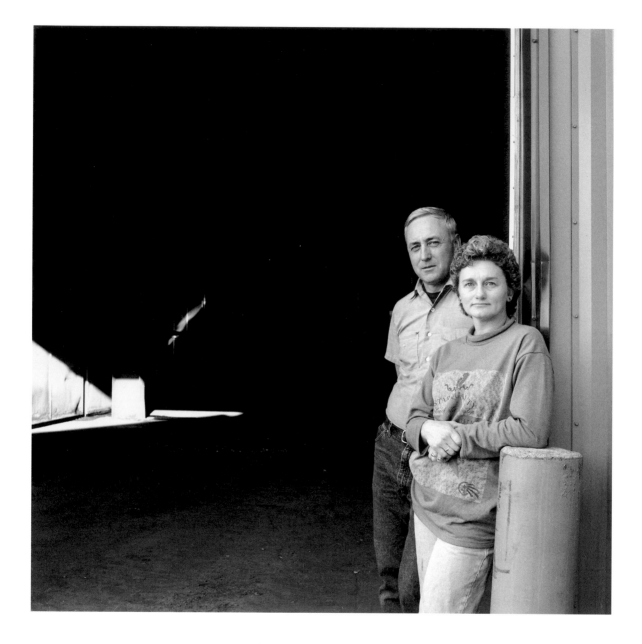

2

I am a novelist, and for me the subjects of so-called portraiture are "characters"—their photographs cannot be regarded as likenesses. Even the subjects of *self*-portraiture become, for me, characters. Perhaps one should simply call the portraits "images" and let it go at that. Their connection to their sources, to the actual human subjects of the photographs, is no stronger or more reductive than is the linkage between the fictional characters of my own novels and the actual human beings living or dead behind them. Mornings, afternoons, and evenings, sitting in my cabin with these black-and-white photographs hanging all around me, while I read my mail and sometimes write these notes or stand by the window and look out at the leafless birch trees—now and then I listen to music on my portable stereo, and from time to time I talk on the telephone with people far from here—has been like residing inside a crowded novel, as if I were reading in the purest way, which is to say, without in any way being

conscious of the reader reading or of the writer writing. It is as if the photographer has hallucinated his figures for me, just as a novelist hallucinates characters for his or her reader. It is as if I have bodily departed from my world and entered the photographer's: I have left my town and journeyed east to Arturo Patten's town, the one based on, or, more accurately, the one *inspired* by, Patten, Maine. We know the name of his town only because he has elected to tell us, but we don't need to know its name: He could as easily have called it Lawford, New Hampshire, or Sam Dent, New York. He could have called it Winesburg, Ohio, or named it after one of those remote lumbering villages in Washington State that the stories of Raymond Carver have made real for us.

With photography there is no intervening linguistic narrative to penetrate, no explicit plot to unravel, no structural scaffolding to climb, and so one reads these images directly, unmediated, with the eye alone. One *observes* them. And from my observations of his characters, I have noticed a few things, made a few general observations, as it were—for instance, that the faces of the men and boys in Arturo Patten's photographs are consistently asymmetrical. Their faces, more than the women's and girls', seem to require dualities, corrective contradictions, lifelong argument between parts and attitude. Theirs are the faces of guilty

executioners. Their eyes and brows and the lines and dents of their cheeks, even their ears, tilt with one another and seem not so neatly paired and matched as do the women's and girls'.

Why is this? What does it *mean*? Is it how they really *are*, the people of Patten, Maine, or is it how Arturo Patten sees them, and how, in fact, he sees all people? More to the point, is it how Arturo Patten sees *us*, the people to whom he has elected to show his photographs? His people, his "characters," are men and boys with asymmetrical, lop-sided faces; or they are women and girls with faces balanced like unwobbling pivots, centered by their carefully aimed eyes—the eyes of placid assassins. So that the question raised by my observation is the question raised by any plausible character, any convincing image of the human: Is this how we truly *are*? Guilty executioners and placid assassins?

What it means to be human, though unchanging, must be learned by us humans over and over again, and it is not portraiture that shows us to ourselves, but imagery, characters, story—all settled and arranged within an observable scale of value, laid out before us in such as way as to distinguish between what is important to human life from what is not, what we are capable of being from what we can never be. For we are the species, the only species, that has to relearn with each generation what it is to be itself.

Arturo Patten has taken us to his town and has shown us ourselves. We need only regard his versions of humanity, and we know ourselves. We will soon forget, of course, and will have to be shown again, but that is not his problem or plan; it's merely in our nature and, as we can see, in the nature of the faces in his photographs as well.

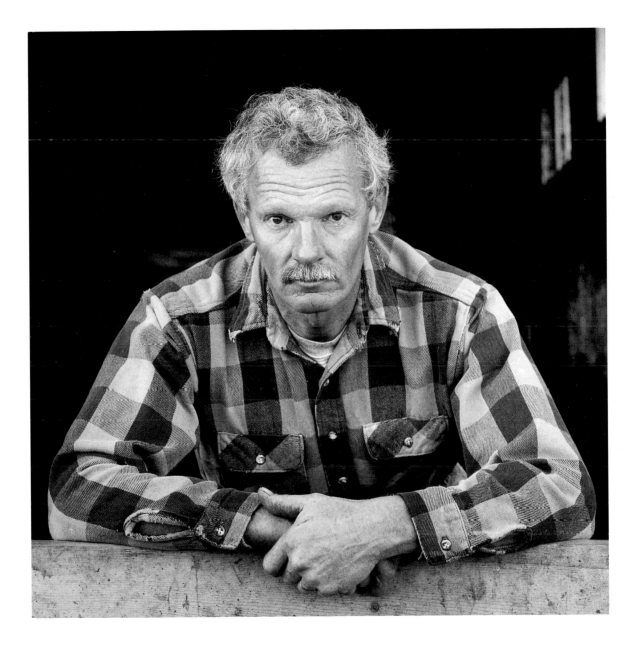

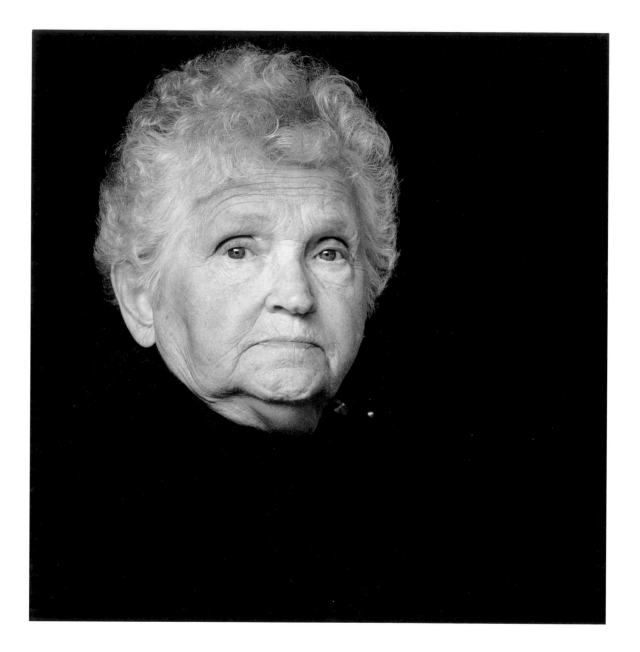

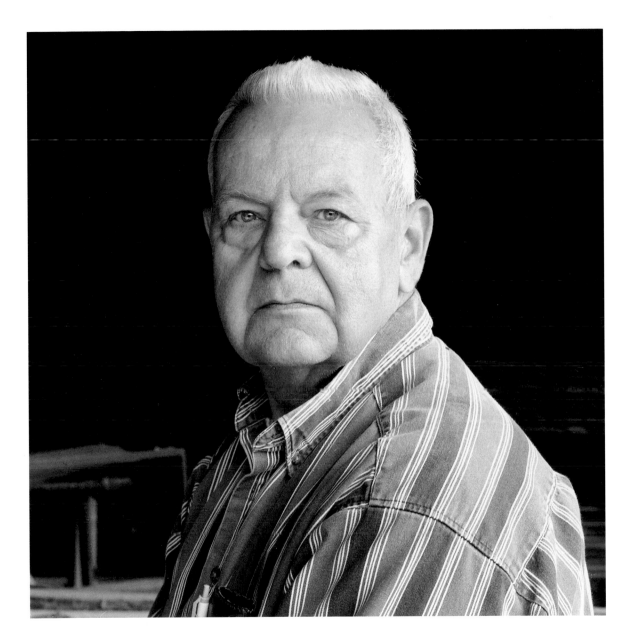

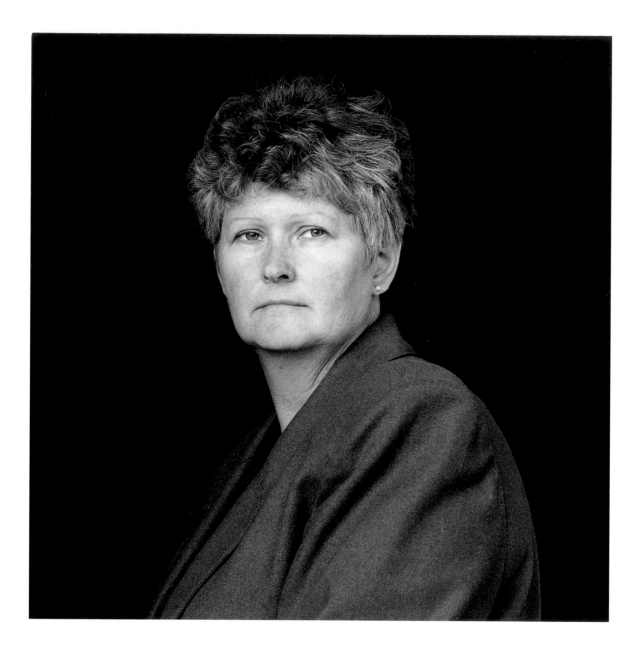

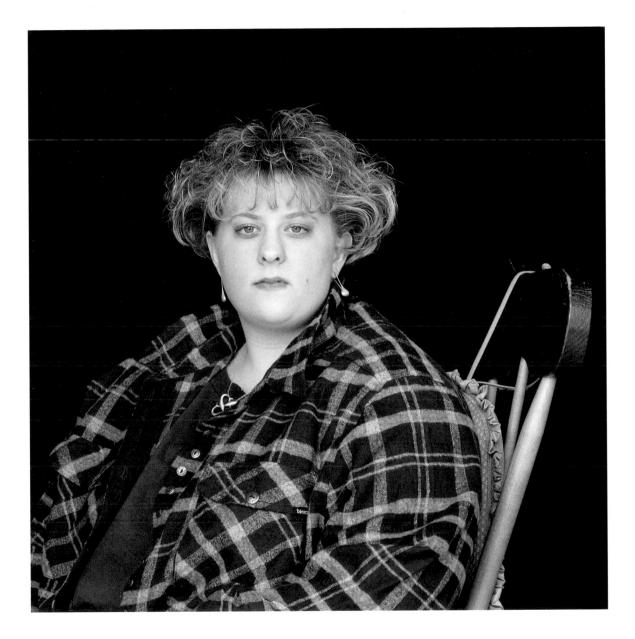

3

Here in his town, however, where he has brought me, I am the invisible stranger. I can see them, the people who live here year-round, but they cannot see me. They stare, gaze, glance, and some of them simply look at me along a shoulder, as if their attention has been turned in my direction and fixed by a sudden noise. Yet, despite the obstinacy of their attention, they cannot see me.

Taken together, there are in this collection forty-four different faces: They reveal grave concern, anxiety, and curiosity; express passing fear, irritation, and bemusement; show anger and impatience and sometimes even compassion—all richly textured emotions laid down before me separately and in opposing pairs and sometimes with three or more woven together. Never boredom, however, and never loneliness; no one seems to think that he or she is the only person in the room. They do not smile or laugh; they leave that for some lighter occasion, or have made it the model for the grimace on their future corpse.

They must realize that I am here—maybe there, somewhere, he's in the room somewhere—and by the expression on their faces, I, too, the viewer, can infer that I am here, for it is clearly a stranger's consciousness (mine?) that has caught their attention. But the stranger is nowhere to be seen. It is as if—a fact unknown to them, known only to me—the camera has struck them blind. They're not looking for what isn't there; no, they're searching for what they can't *see*.

Or, to look at it strictly from their point of view, we are all at a funeral together, the unexpected, puzzling funeral of the recently arrived stranger, and I am his grinning corpse in the open coffin. The townspeople are not blind, no matter what I wish to think. They see me very clearly. Look at their eyes. The furrowed forehead of the village priest, Blattner; the lifted left eyebrow of Stevens, the potato farmer; the shy guardedness of the bulky young man in the striped sweater shielding his glamorous mother (shielding her from whom? from *me*?); the cold, examining eye of McIntire, the banker—they all appear to be looking at someone who cannot look back, someone, however, whose inability to return their gaze does not make them feel safe or disinterested.

When it comes to the act of consciously *seeing*, of having one's brain invaded via the optic nerve by the image of a human face, the people of Patten,

Maine, and I, thanks to these photographs, are that different, are that opposed to one another: One sees, the other is seen. And yet, despite that, we are a community. A camera has brought us together, and then it has separated us and has told us so. A camera has gathered all the people of the town together with their stranger in a dusk-darkened room, its board floor covered with dingy linoleum, the smell of the air tainted by unburned kerosene. The day's last light descends from a single high window. It is November. Outside a cold dog tied to a cast-off tire in a bare dirt yard barks uselessly. Then we hear the quick clatter of the shutter, and in that instant the man who operates the camera, a stranger from Rome, Italy, a man who says his name is Arturo Patten, the same surname as the name of the *town*, for heaven's sake, has pointedly, violently separated us, has made the townspeople blind, has made me invisible to them.

Or if, after the camera eye has opened and closed again, they insist on being sighted—as indeed half the time, whenever I manage the trick of regarding the photographs from their point of view, they seem to do—then the violence turns out to have been done to me alone, to the one who views these photographs, and I am not invisible now, I am dead and am being looked at by the living, by the people of Patten, Maine, who are secretly relieved to be watched no more by the

stranger, the fellow who, uninvited, came in from the south or the east—the fellow from Italy whom no one knew.

Arturo Patten is merely the camera; I, you—anyone who pauses before these photographs and looks at them—that man or woman is invited to become the photographer. That is Arturo Patten's gift to us. And his willingness to play the corpse in the coffin is his gift to them. The townspeople say to one another: "Too bad about the stranger. But then, who knew him when he was alive, anyhow? We can only know him dead like this, lying in his coffin, eyes closed. We never noticed him before. He was here among us for months, yet all that time invisible. Odd. Now we see him, then we didn't."

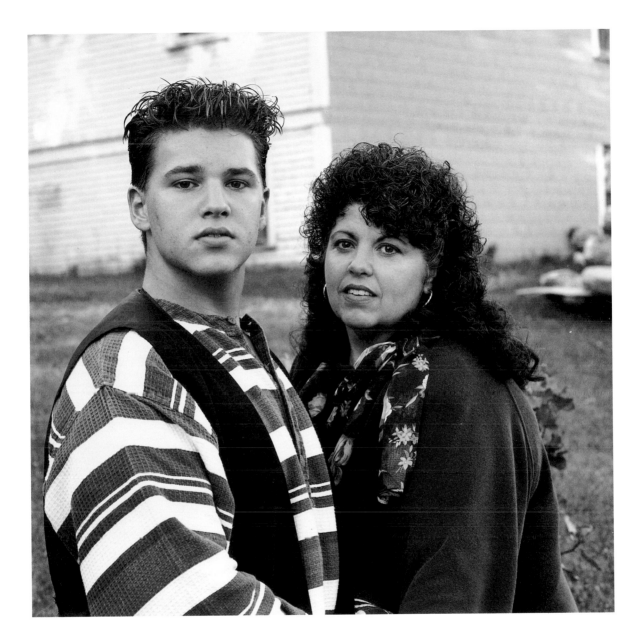

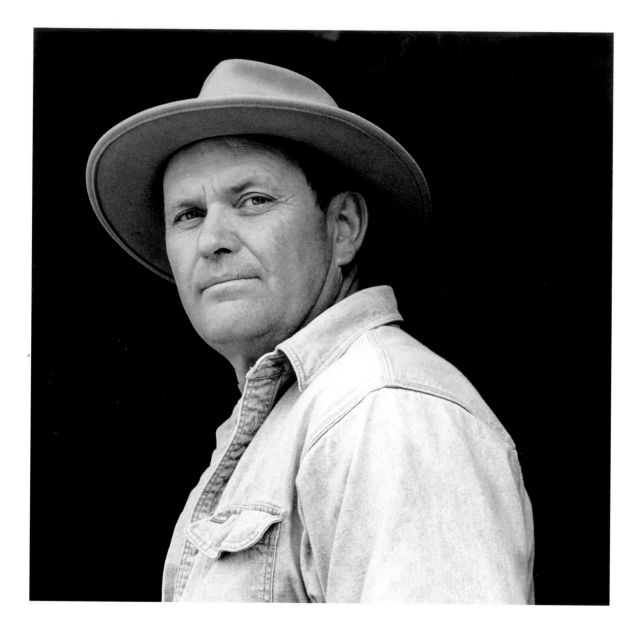

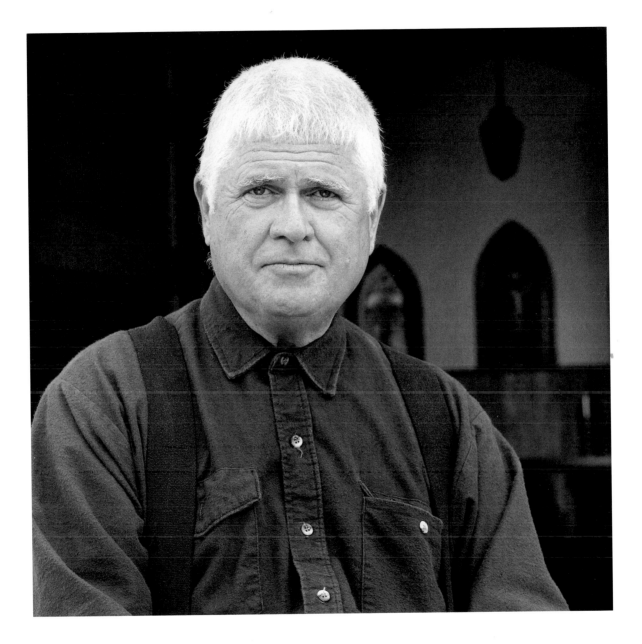

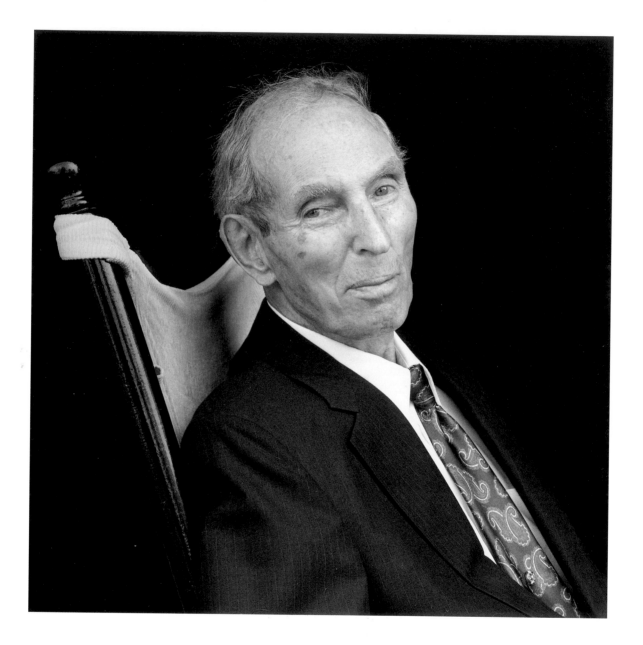

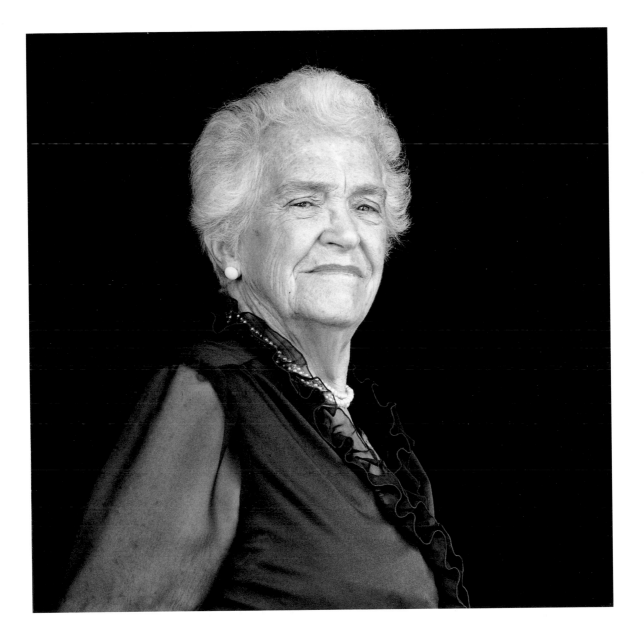

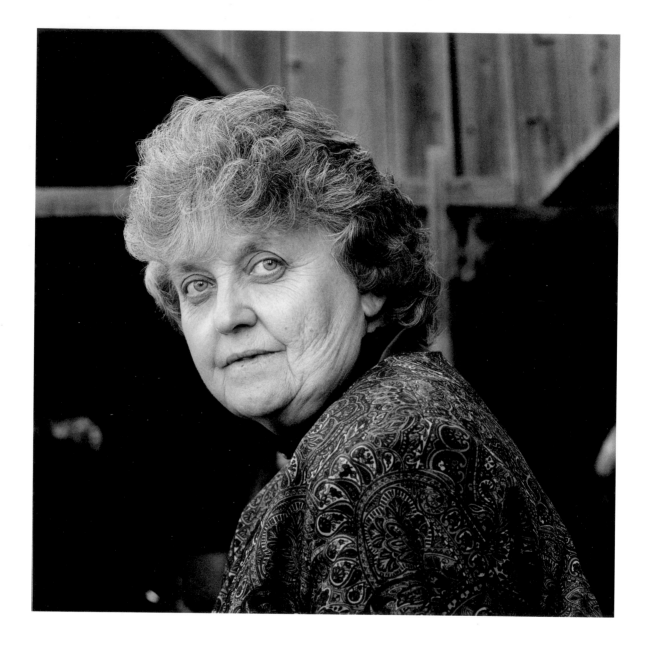